ANDY HALL's photographic reputation has gained international recognition as a result of the success of his books, *A Sense of Belonging to Scotland*, the favourite places of Scottish personalities, and *Touched by Robert Burns* which was launched by Scotland's First Minister, the Rt. Hon. Alex Salmond at Edinburgh Castle on St Andrew's Night in 2008.

A Bachelor of Education graduate of Aberdeen University and a resident of Stonehaven, Andy has spent 20 years capturing the characteristic clear light of his local area (where he conducts photography tuition weekends) and throughout Scotland. He has presented illustrated talks on his photography in Scotland, in London and in Brussels for Scotland Europa. His books and talks have been presented at conferences and for overseas visitors to provide an insight into the beauty and diversity of Scotland's landscape.

Andy chaired the panel of judges for the official Homecoming Scotland Photography Competition in 2009. His images have been exhibited in the new Robert Burns Birthplace Museum in Alloway, Ayrshire.

A Sense of Belonging to Scotland: Volume One was used by former First Minister Jack McConnell for his ministerial visit to China in 2004. Ewan McGregor described it as 'The most beautiful collection of photographs of Scotland that I have ever seen!'

Acknowledgements

Luath Press would like to thank the following authors, publishers and estates who have generously given permission to reproduce poems and book extracts:

Front cover image by Andy Hall; p8 from *Letters from Hamnavoe* by George Mackay Brown, reproduced courtesy of Steve Savage Publishers; p10 from *A Man in Assynt* by Norman MacCaig, reproduced courtesy of Birlinn Ltd; p12 from *Lanark* by Alasdair Gray, reproduced courtesy of Canongate; p16 from 'The White Sands of Morar' by Alan Riach, reproduced courtesy of University of Glasgow; p18 from *The Cone Gatherers* by Robin Jenkins, reproduced courtesy of Canongate; p20 from 'Eileanan'/'Islands' reproduced courtesy of Maoiios Caimbeul; p30 from 'Open the Doors' by Edwin Morgan, reproduced from *Collected Poems*, courtesy of Carcanet Press Ltd; p38 from 'The Tree of Strings' by Sorley MacLean, by Luath Press Ltd; p42 from *Rainbow* by Angus Peter Campbell, reproduced courtesy of Polygon; p44 from 'Loch', reproduced courtesy of Helen Lamb; p48 from *Outer*, reproduced courtesy of Polygon; p50 from *Edwin Muir: An Autobiography*, reproduced courtesy of Canongate; p54 from *Montrose* by Violet Jacob, reproduced courtesy of Malcolm UL Hutton; p56 from 'Dundee' taken from *The Myth of the Twin* by John Burnside, published by Jonathan Cape, reprinted by permission of The Random House Group Limited; p60 from *Joan Eardley RSA* by Cordelia Oliver, reproduced courtesy of Mainstream Publishing; p62 from 'Edge' featured in Iona by Kenneth Steven © St Andrew Press, 2000. Used by permission; p68 from 'Scotland', reproduced courtesy of Alexander Gray; p74 from *The Wilderness* by Kathleen Raine, reproduced courtesy of The Literary Estate of Kathleen Raine; p76 from *And On This Rock* by Donald S. Murray, reproduced courtesy of Birlinn Ltd; p78 from 'Seagulls' by Iain Crichton Smith, reproduced from *New Collected Poems*, courtesy of Carcanet Press Ltd; p82 from *The Great Wood* by Jim Crumley, reproduced courtesy of Birlinn Ltd; p84 from *The Faithful Heart* by Marion Angus, reproduced courtesy of Alan J Byatt; p86 from *The Living Mountain* by Nan Shepherd, reproduced courtesy of Canongate; p94 from 'The Little White Rose' by Hugh MacDiarmid, reproduced from *Complete Poems Volume 1*, courtesy of Carcanet Press Ltd.

Scotland's Still Light

A Photographer's Perspective on Landscape and Literature

ANDY HALL

Luath Press Limited

EDINBURGH

www.luath.co.uk

This book is dedicated to the memory of
Michael Marra
whose art touched the soul of Scotland.

First published 2014
Reprinted 2014

ISBN: 978-1-908373-79-3

The paper used in this book is manufactured to ISO 14001 and EMAS
(Eco-Management & Audit Scheme) international standards, minimising negative
impacts on the environment and using pulp from sustainable forests.

The publishers acknowledge the support of

towards the publication of this volume.

Printed and bound by
Gomer Press Ltd., Ceredigion

Typeset in 12pt Quadraat and Bodoni by 3btype.com

FOREWORD

Andy Hall has a unique vision. His work has what can only be described as the quality of 'sweeping poetics'. So to come to a creative place where word and image synthesise is very much a logical and organic step on the journey of this dedicated artist.

Andy's purity of vision and his 'common man' commitment to image give his pictures not just a 'down to earth' quality but an 'of the earth' quality. As a result, his images, like all work that is so deeply rooted, soar to aesthetic heights.

This current fusion, with works such as Buchan's trek in the Galloway hills from *The Thirty-Nine Steps*, is a perfect chiaroscuro of time and place.

Still Light is a masterwork.

Brian Cox, actor

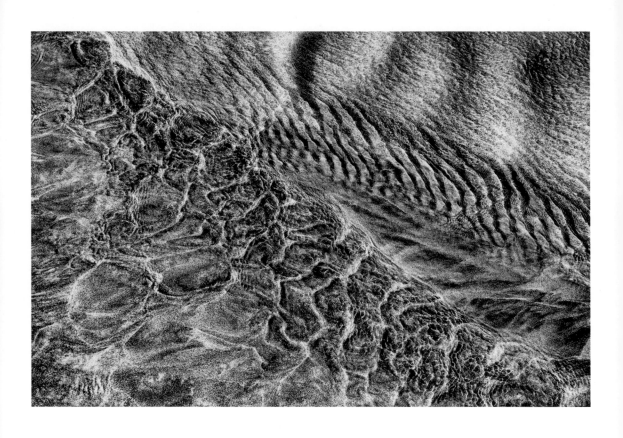

INTRODUCTION

THE IDEA FOR THIS BOOK came to me very early on a sunny August morning at Calgary Bay on the Isle of Mull. Having the whole beach to myself, I walked barefoot through the shallow water, backwards and forwards, and from end to end, for what must have been over an hour.

With the early sunlight glinting on the surface of the turquoise water, lines from Edwin Muir's poem *Childhood* entered my mind –

> In thought he saw the still light on the sand,
> The shallow water clear in tranquil air,
> And walked through it in joy from strand to strand.

Still Light explores the relationship between photographic imagery and the words of some of Scotland's most highly-respected writers. It is not an attempt to illustrate the texts but to give a sense of place through the combination of words and images. Sometimes a whole piece is selected, sometimes a paragraph or verse, a few lines or occasionally, a single line.

All of the images that follow have evolved from a photographic study of the unique quality of light that prevails in the exquisite diversity of Scotland's landscapes and cities.

Andy Hall

The essence of Orkney's magic is silence, loneliness and the deep marvellous rhythms of sea and land, darkness and light.

from Letters from Hamnavoe by *George Mackay Brown* (1921–1996)

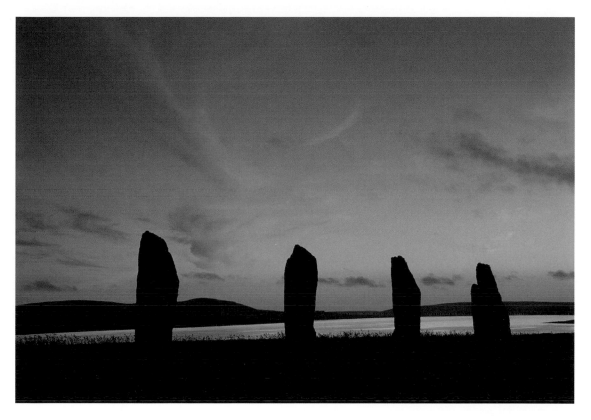

The Ring of Brodgar, Orkney

Who possesses this landscape? –
The man who bought it or
I who am possessed by it?

False questions, for
the landscape is
masterless
and intractable in any terms
that are human.

from A Man in Assynt
by Norman MacCaig (1910–1996)

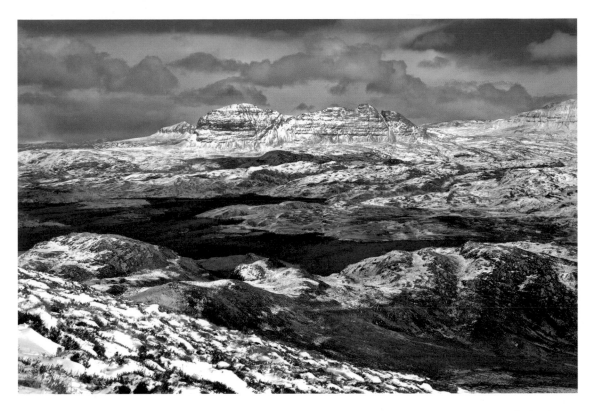

Assynt, Sutherland

After a moment of silence the voice said in a
dry academic voice The river Clyde enters the
Irish Sea low down among Britain's back hair
of islands and peninsula. Before widening to
a firth, it flows through Glasgow, the sort of
industrial city where most people live nowadays
but nobody imagines living. Apart from the
cathedral, the university gatehouse and a gawky
medieval clocktower, it was almost all put up in
this and the last century –

'I'm sorry to interrupt again,' said Lanark,
'but how do you know this?
Who are you anyway?'

A voice to help you see yourself.

from Lanark by Alasdair Gray (1934–)

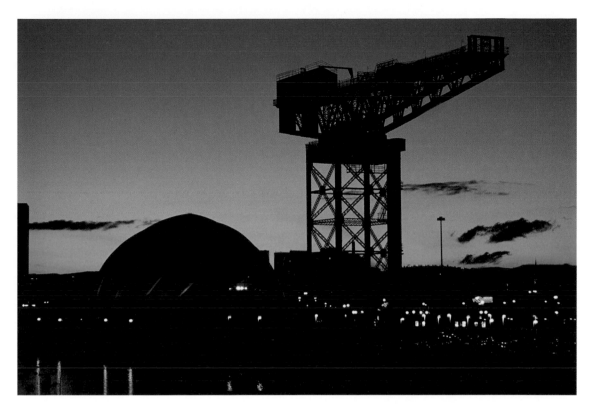

Glasgow

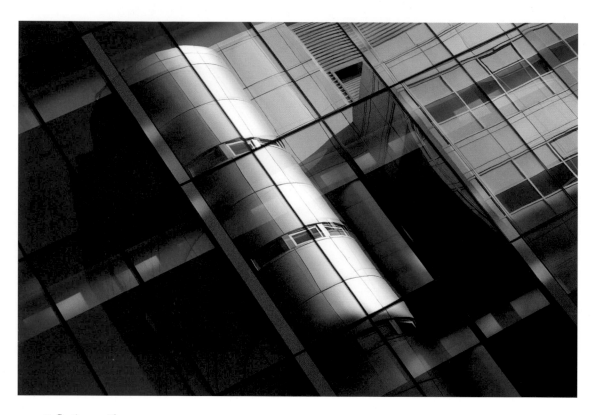

Reflecting on Glasgow

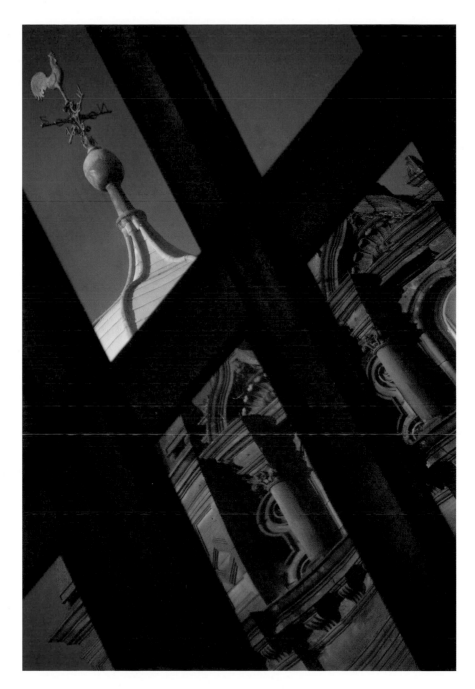

Then suddenly, somehow, this transformation: the heavy air has lifted off,
the sands return to white, the sea is calm, the melody floats out
on oboes and clarinets and through the endorsing pulse
of a softly singing rhythm, entering gently another world
of harp, horn and solo violin.

*from The White Sands of Morar by Alan Riach (1957–), describing a
visit to Morar by composer Arnold Bax in autumn 1928, as represented in
the coda of the last movement of Bax's Third Symphony.*

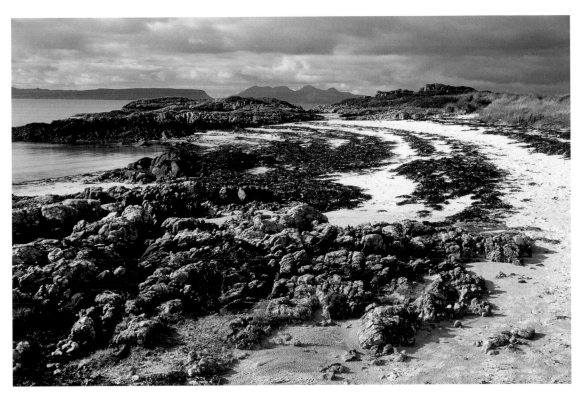

The White Sands of Morar

The time came when, thrilling as a pipe lament across the water, daylight
announced it must go: there was a last blaze of light, an uncanny clarity,
a splendour and a puissance; and then abdication began. Single stars
appeared, glittering in a sky pale and austere. Dusk like a breathing drifted
in among the trees and crept over the loch. Slowly the mottled yellow of
the chestnuts, the bronze of beech, the saffron of birches, all the
magnificent sombre harmonies of decay became indistinguishable.
Owls hooted. A fox barked.

from The Cone Gatherers *by Robin Jenkins (1912–2005)*

Ancient Caledonian Forest

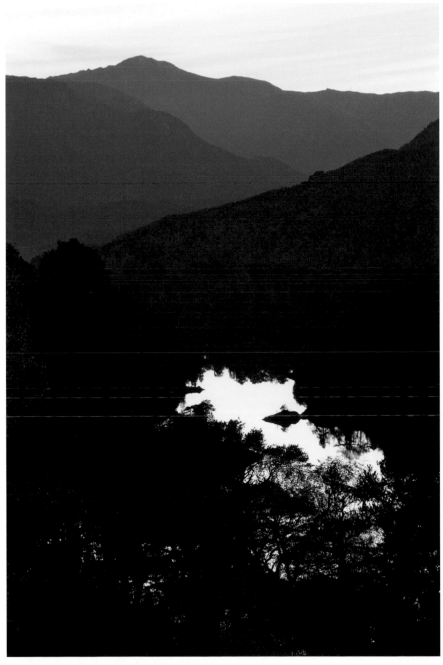

And there is an island in the dusk,
assured, dark, repelling,
its foundation in a fading time.

from Islands *by Myles Campbell* (1944–)

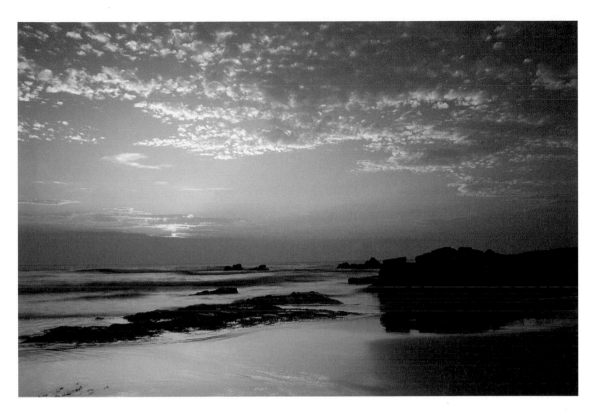

Islay

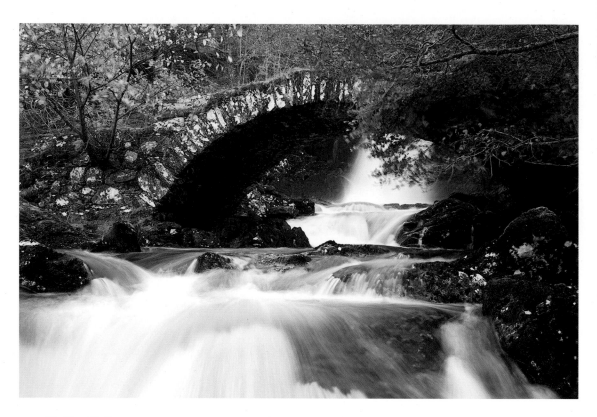

Highland Falls

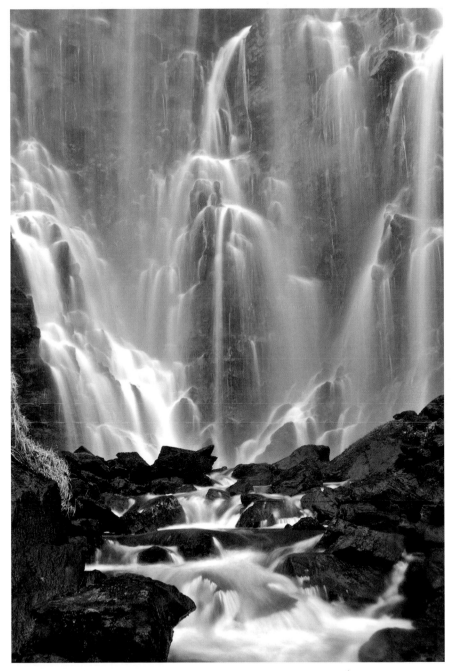

The folk who wrote and fought and were learned,
teaching and saying and praying, they lasted but
as a breath, a mist of fog in the hills, but the land
was forever, it moved and changed below you,
but was forever.

from Sunset Song *by James Leslie Mitchell*
(Lewis Grassic Gibbon, 1901–1935)

The Mearns, Kincardineshire

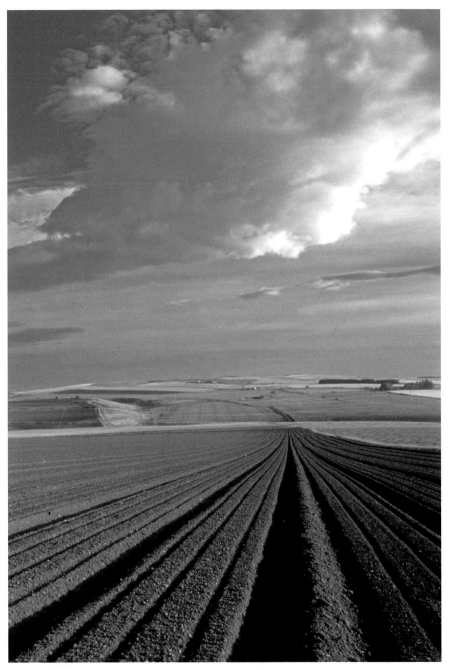

It is the beautiful that I thus actually recall,
the august airs of the castle on its rock,
nocturnal passages of lights and trees,
the sudden song of the blackbird in a suburban
lane, rosy and dusky sunsets...

from Early Memories *by Robert Louis Stevenson*
(1850–1894)

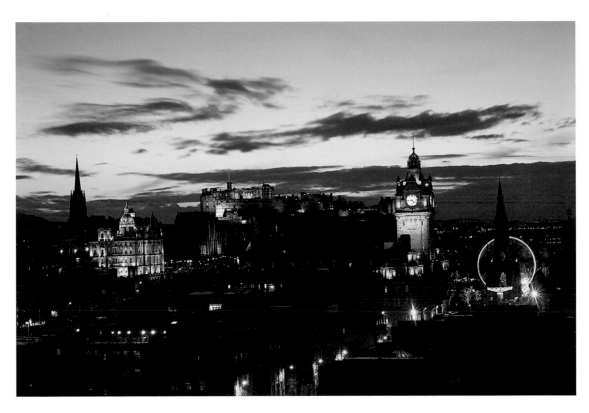

Edinburgh

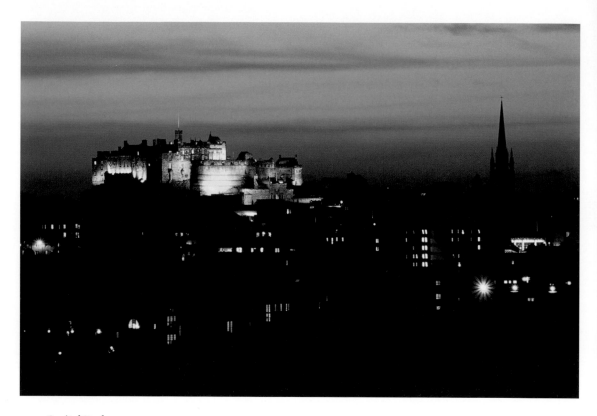

Capital Dusk

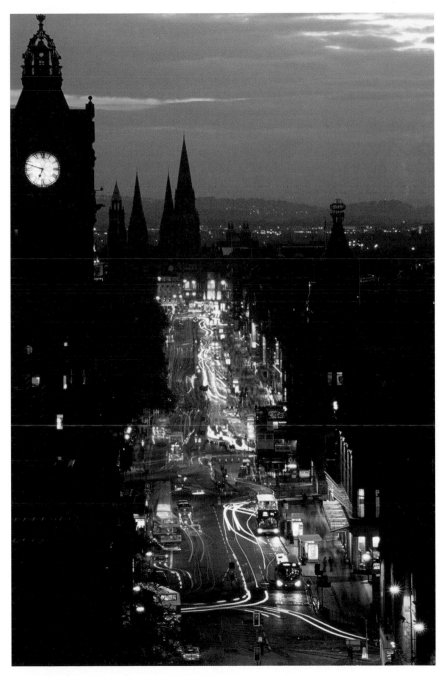

Open the doors! Light of the day, shine in; light of
 the mind, shine out!
We have a building which is more than a building.
There is a commerce between inner and outer,
between brightness and shadow, between the
 world and those who think about the world.
Is it not a mystery? The parts cohere, they come
 together
like petals of a flower, yet they also send their
 tongues
outward to feel and taste the teeming earth.

from Open The Doors *by Edwin Morgan*
(1920–2010) for the opening of the
Scottish Parliament, 9 October 2004.

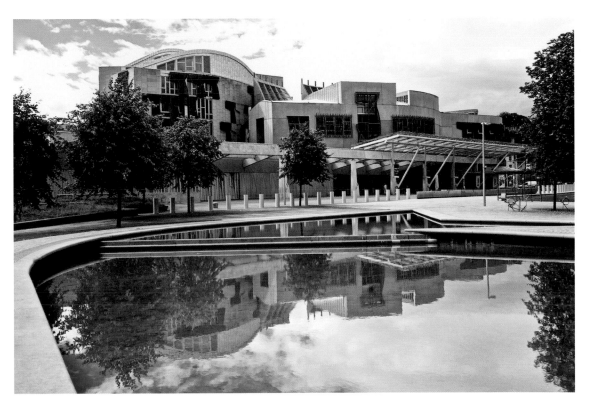

Scotland's Parliament, Edinburgh

It was a gorgeous spring evening with every hill showing as clear as a cut amethyst. The air had the queer, rooty smell of bogs, but it was as fresh as mid-ocean, and it had the strangest effect on my spirits. I actually felt light-hearted.

I might have been a boy out for a spring holiday tramp, instead of a man of thirty-seven very much wanted by the police. I felt just as I used to feel when I was starting for a big trek on a frosty morning on the high veld…

There was no plan of campaign in my head, only just to go on and on in this blessed, honest-smelling hill country, for every mile put me in better humour with myself.

from The Thirty-Nine Steps *by John Buchan*
(1875–1940)

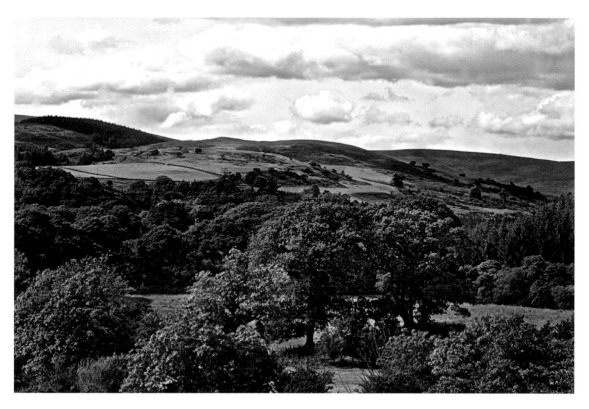

The Galloway Hills

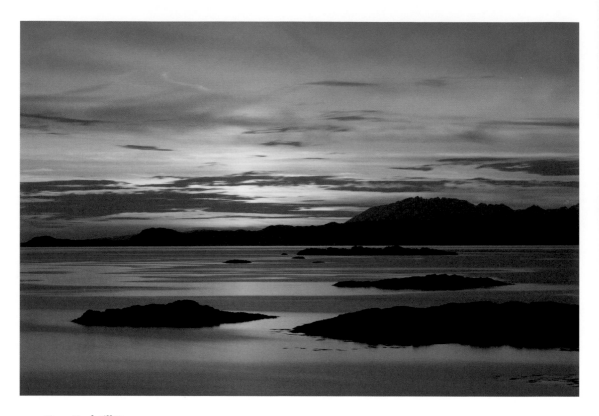

From Dusk till Dawn

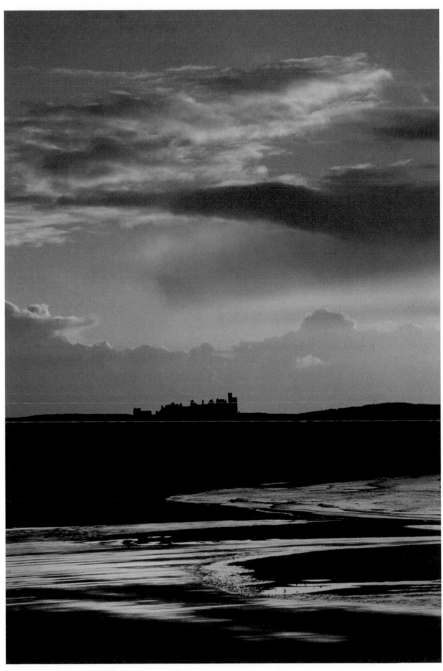

On my lonely walks I have often thought how fine it would be to have the company of Burns. And indeed he was always with me, for I had him in my heart. On my first long walk from Indiana to the Gulf of Mexico, I carried a copy of Burns's poems and sang them all the way. Wherever a Scotsman goes, here goes Burns. His grand, whole, catholic soul squares with the good of all; therefore we find him in everything, everywhere.

John Muir (1838–1914) naturalist and founder of the National Parks system in the USA (born in Dunbar, Scotland)

Statue of Robert Burns, Dumfries

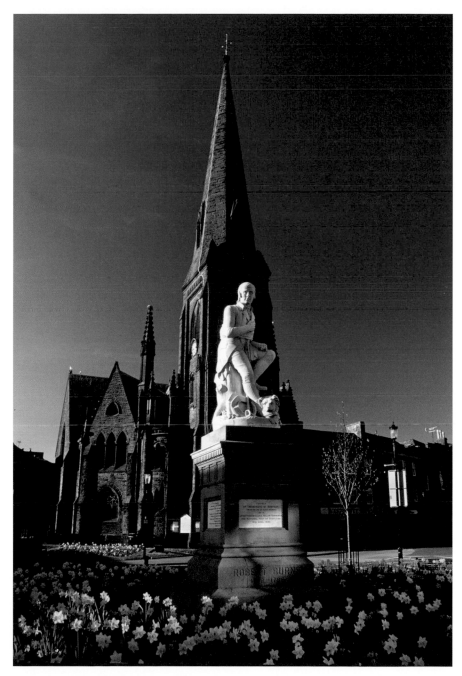

On the hardness of rocks
is the ordered thought,
on the bareness of mountains
is the forthright verse,
on a living summit
is the might of talents,
on a white summit
the garden that is not named.

from The Tree of Strings
by Sorley MacLean (1911–1996)

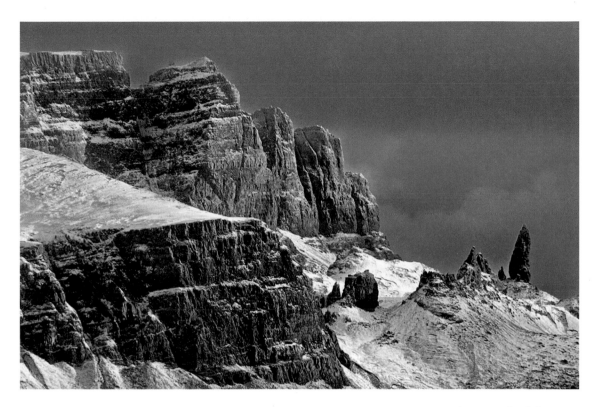

The Storr, Isle of Skye

Hebridean Rock

Therefore,
despite every desire
I am still in love: despite
the Boulevard de Richelieu, and Molly Malone,
and even Luskentyre,
this remains:

the machairs of Uist
and Iain Sheonaidh
crouched in the pouring rain, and you,
my darling, steadfast, through
every deluge and bow.

from Rainbow by Angus Peter Campbell (1952–)

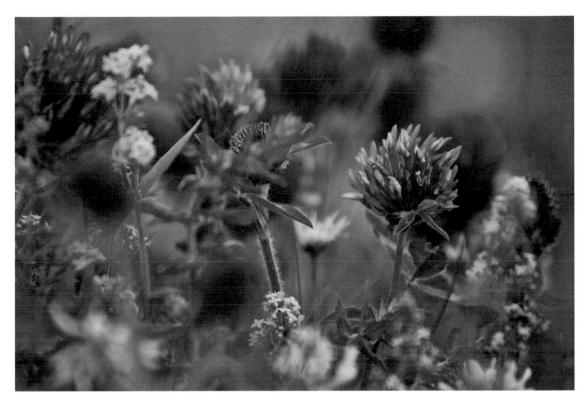

Machair, South Uist

I have my moods
vagary and whim flit across my surface
I am a looking-glass for the sky
a cradle for mountainous shadows
sometimes wind-ruffled
but deep down untroubled.

from Loch by Helen Lamb (1956–)

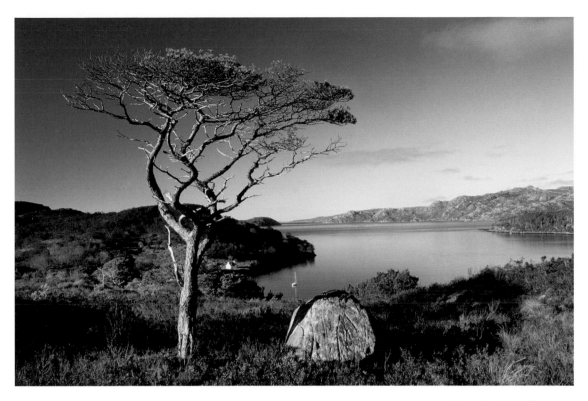

Upper Loch Torridon

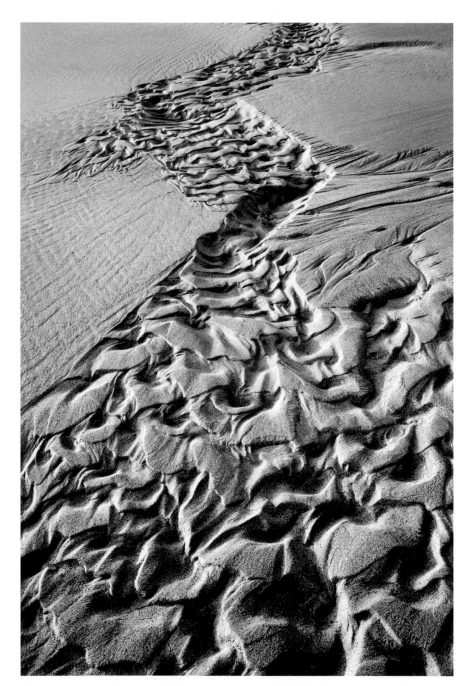

46

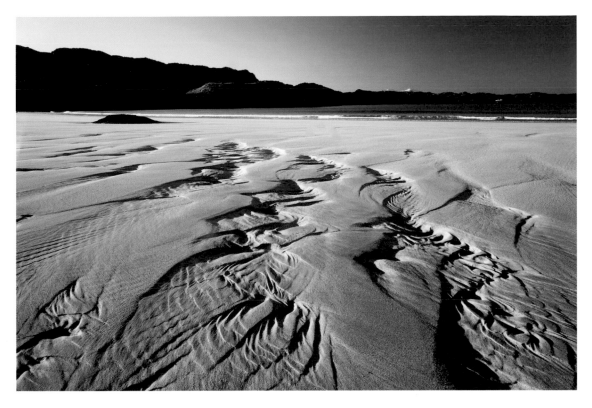

Sutherland Sand

And so we go to Callanish to see the stones.
Another world entirely.
Chill at the bone
we walk the longest limb avenue of stones all
twice as tall as any man.
Nowhere on this island can you find this stone.
Who brought?
Hard and how far? Why?

from Outer by Liz Lochhead (1947–)

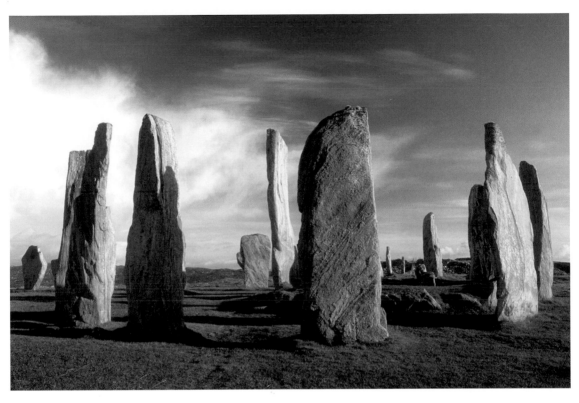

Callanish Stones, Isle of Lewis

I cannot remember much about the actual building of the boat, except for the bending of the boards in steam, the slow growth of the sides as one smooth ply of wood was set on another, the sides bulging in a more swelling curve from bow to stern as the days passed in delicious slowness...

from Edwin Muir: An Autobiography,
Edwin Muir (1887–1959)

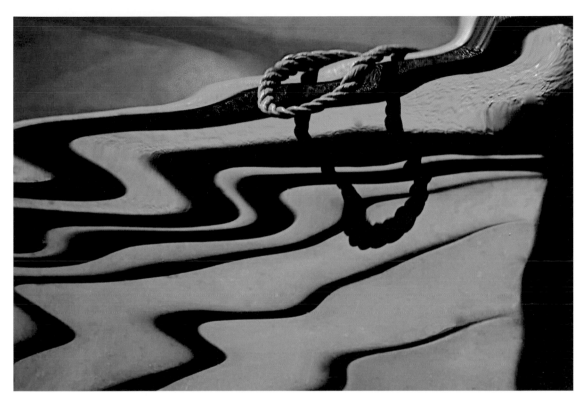

Stonehaven Harbour Reflection

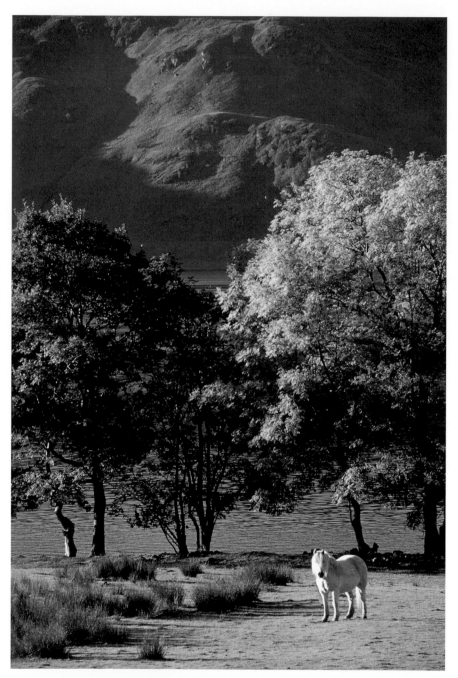

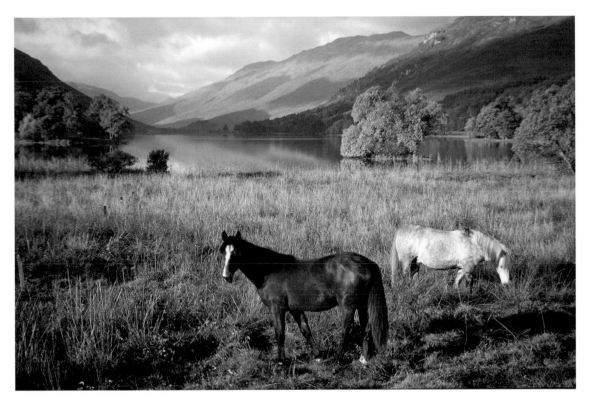

Autumn Horses

I winna seek to bide
Awa owre lang,
Gin but Ye'll let me gang
Back to yon rowin' tide
Whaur aye Montrose – my ain –
Sits like a queen,
The Esk ae side, ae side the sea whaur she's set her lain
On the bents between.

from Montrose by Violet Jacob (1863–1946)
describing a ww1 soldier praying to return to
Montrose from the battlefields of France.

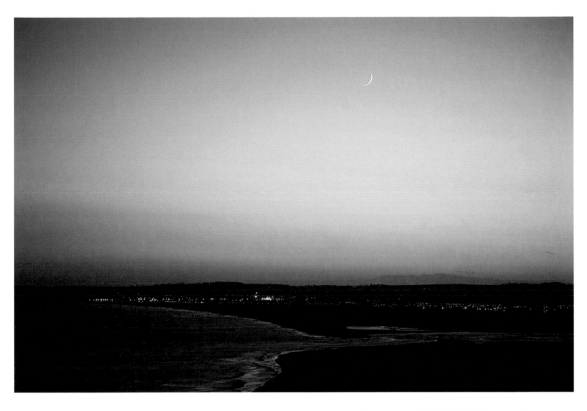

Montrose and North Esk Estuary, Angus

The streets are waiting for a snow
that never falls:
too close to the water,
too muffled in the afterwarmth of jute,
the houses on Roseangle
opt for miraculous frosts
and the feeling of space that comes
in the gleam of day...

from Dundee by John Burnside (1955–)

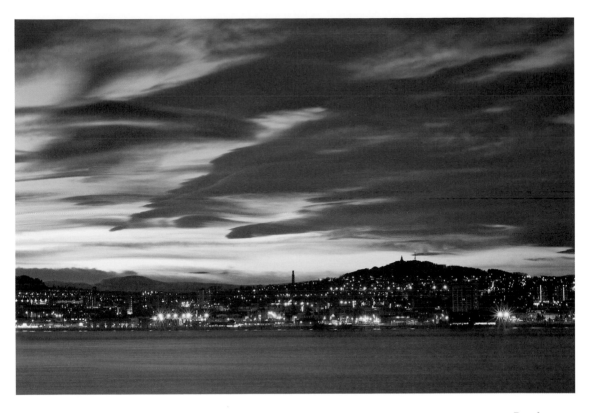

Dundee

Achmelvich Shore

Despite all the hardships involved, Joan loved
the winter at Catterline. Almost, one feels,
the battle with the elements stimulated and
fed her creative urge.

from Joan Eardley, RSA
by Cordelia Oliver (1923–2009)

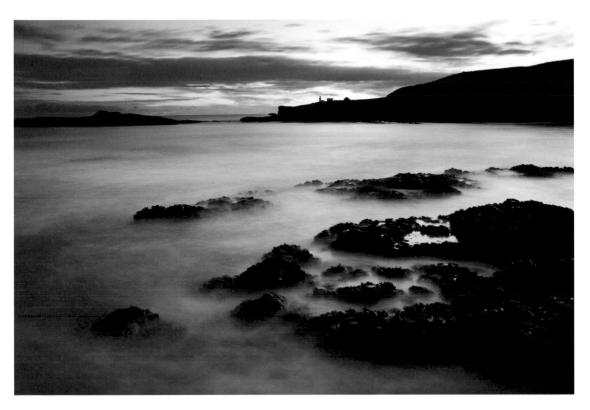

Catterline Bay, Kincardineshire

If you come here in summer
It is islands and islands as far west as America.
Sudden thunderings of cloud,
Light blessing the sea,
Orchids blowing across every moorland.

from Edge by Kenneth Steven (1968–)

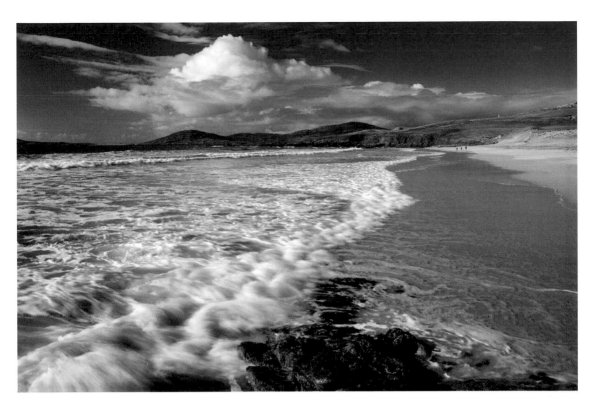

The Isle of Harris

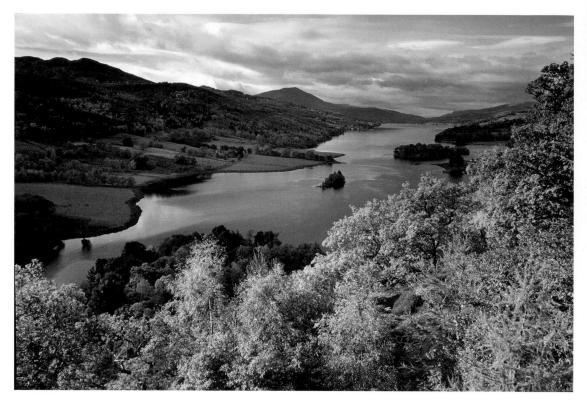

Perthshire in Autumn

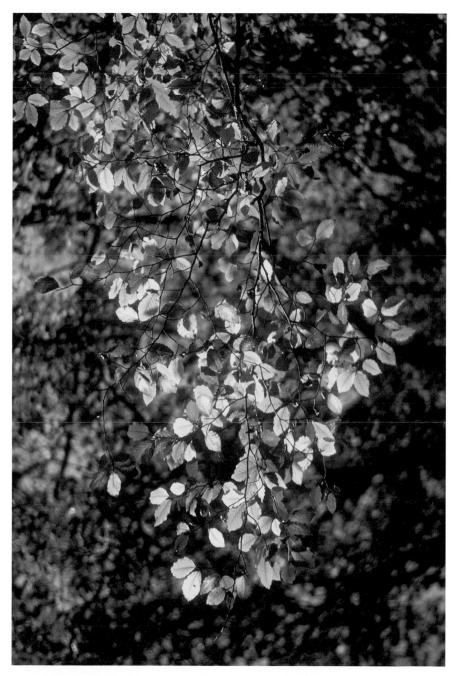

The braes ascend like lofty wa's,
The foaming stream deep-roaring fa's,
O'erhung wi' fragrant spreading shaws,
The birks of Aberfeldy.

from The Birks of Aberfeldy
by Robert Burns (1759–1796)

The Birks of Aberfeldy

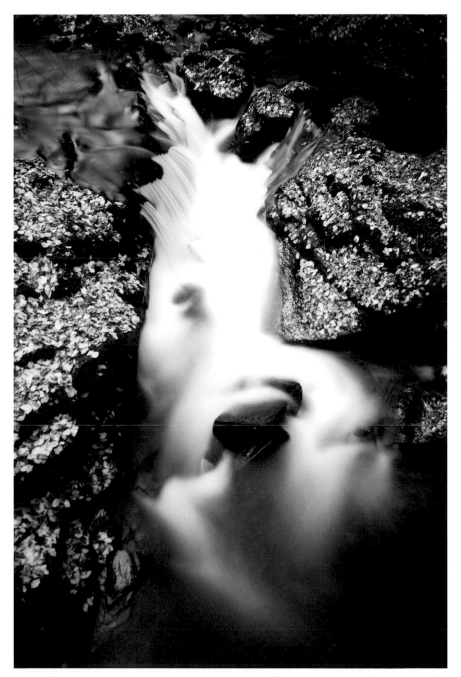

This is my country,
The land that begat me
These windy spaces
Are surely my own.
And those who here toil,
In the sweat of their faces,
Are flesh of my flesh
And bone of my bone.

from Scotland by Alexander Gray (1882–1968)

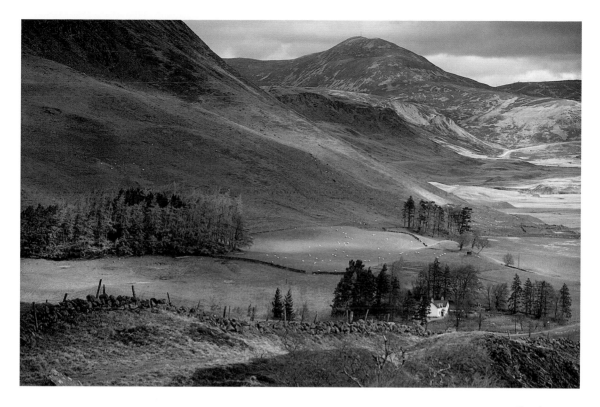

Glenshee

I think there is no such sweep and breadth of sky anywhere. The 'spacious firmament on high' sweeps round and round, with the distant hills in soft outline against its tints of pearl, and the levels of the sea melting into it, yet keeping their imperceptible line of distinction, brimming over in that vast and glorious cup.

from The Rush of the Aurora Borealis
by Margaret Oliphant (1828–1897)
describing St Andrew's Bay.

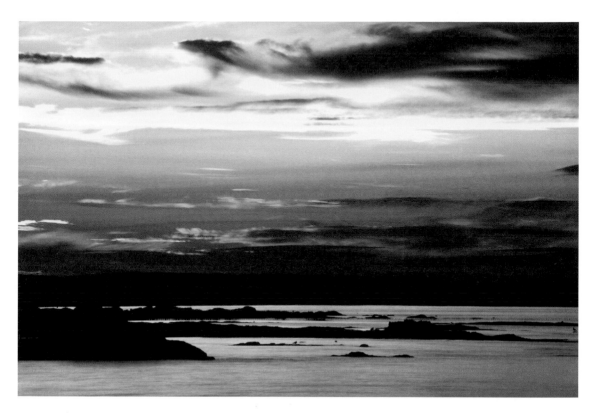

St Andrew's Bay

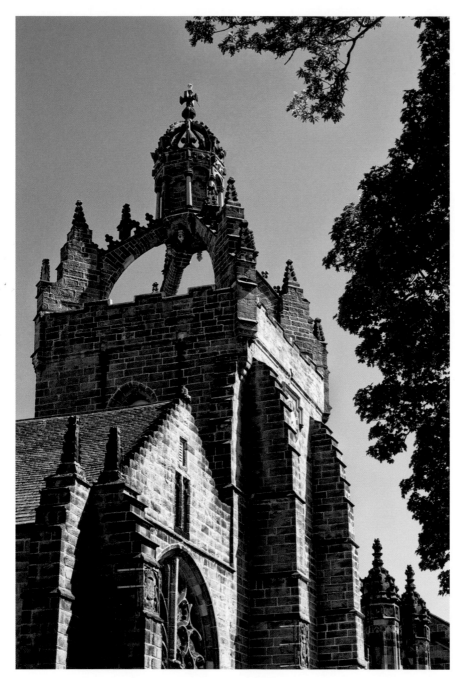

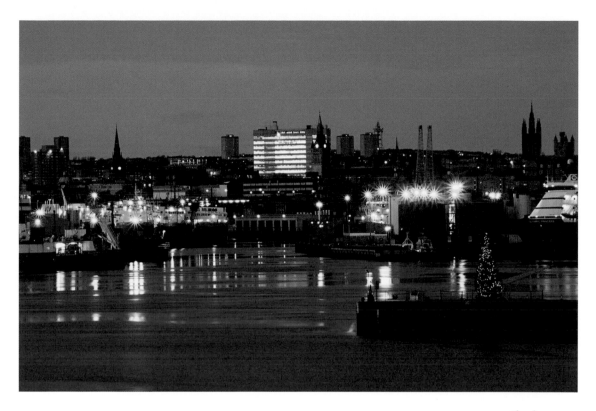

Aberdeen

A child I ran on a withered moor
Crying out after those great presences who were
 not there,
Long lost in the forgetfulness of the forgotten.

from The Wilderness by *Kathleen Raine* (1908–2003)

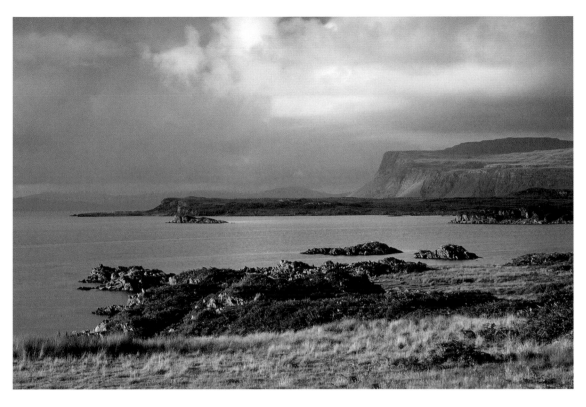

The Burg, Isle of Mull (also known as The Wilderness)

For each man that looked at it, the image did much
more than summon up a vision of Moena, far away.
It expressed all that they had wished for. A voyage
towards a place of peace from which they had been
taken by the mad and frenzied dreams of others.
A return to their homeland...

from And On This Rock, The Italian Chapel, Orkney
by Donald S. Murray (1957–), describing the chapel built
by Italian prisoners-of-war on Orkney in World War Two.

The Italian Chapel, Lamb Holm, Orkney

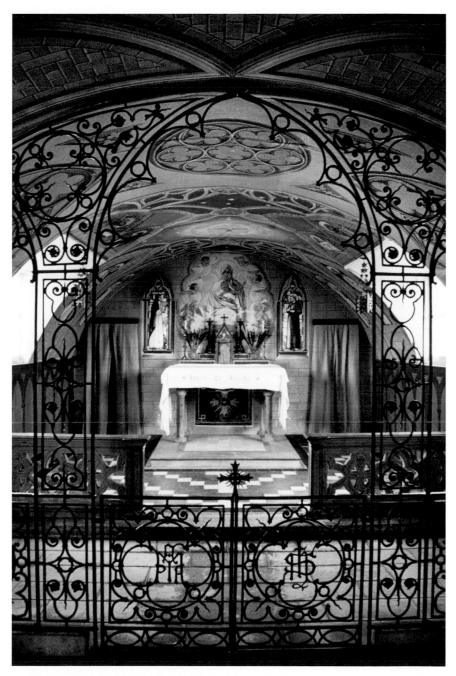

Your circles cannot touch. No tangent may
even lightly curve through blue to join you to
a seagull's world which at the centre is
the single-headed seagull in the blue
image you make for it, its avarice
its only passion that is really true.

from Seagulls *by Iain Crichton Smith* (1928–1998)

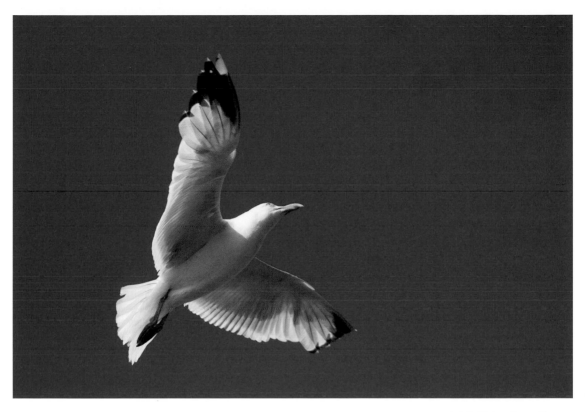

High Flying Seagull

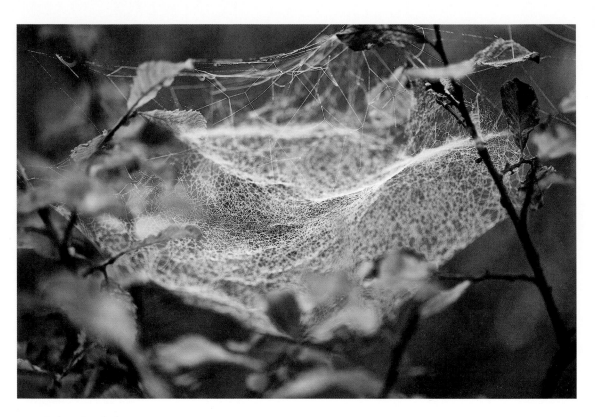

Sylvan Strathglass

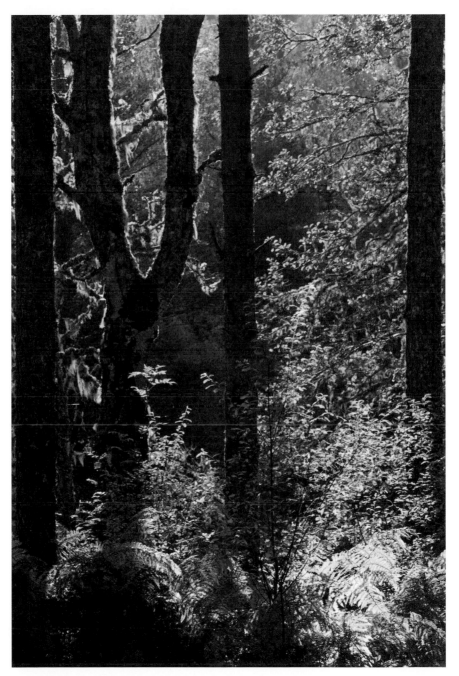

The next day we went out to the pinewood in Glen Affric and he played the pipes again, but this time he played pibroch, and his slow, slow march as he played had something of the strut and the omnipotence of the cock capercaillie about it. The music rose and hung in long sinuous clouds on the still air of the morning and eddied among the pine trees, and its pulse was like golden eagle wingbeats.

from The Great Wood *by Jim Crumley (1947–)*

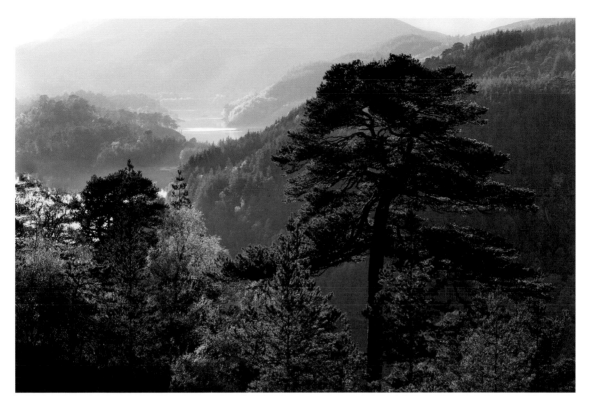

Glen Affric

There cam' a man from Brig o' Feugh,
Whaur I was wild and young;
I kent him by his heather step
And the turn upon his tongue.

He spak' o' crofters on the hill,
The shepherd from the fauld,
Simmers wi' the flourish sweet,
Winters dour and cauld...

from The Faithful Heart
by Marion Angus (1865–1946)

The River Feugh, near Banchory

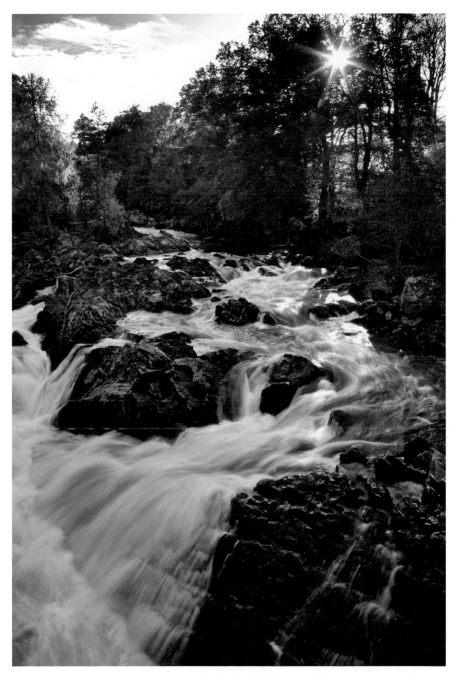

The freezing of water is another mystery...

But the struggle between frost and the force in running water is not quickly over. The battle fluctuates, and at the point of fluctuation between the motion in water and the immobility of frost, strange and beautiful forms are evolved.

from Frost and Snow *in* The Living Mountain
by Nan Shepherd (1893–1981)

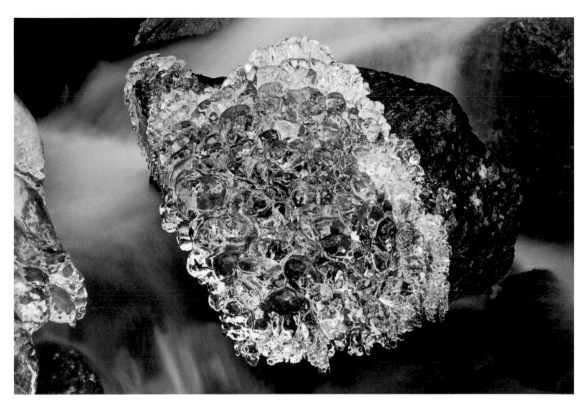

The Cairngorms National Park

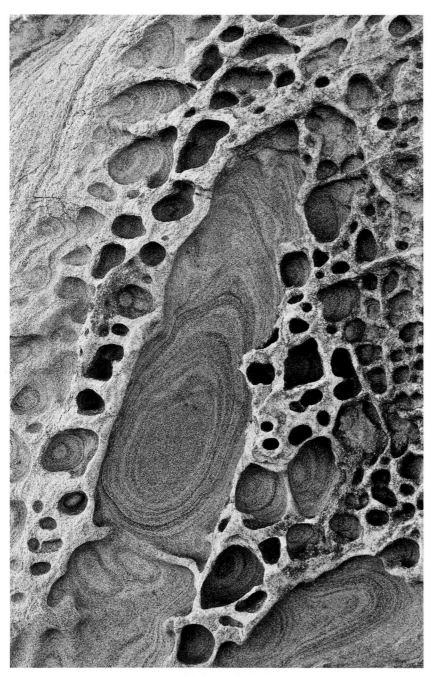

Sandstone Honeycomb

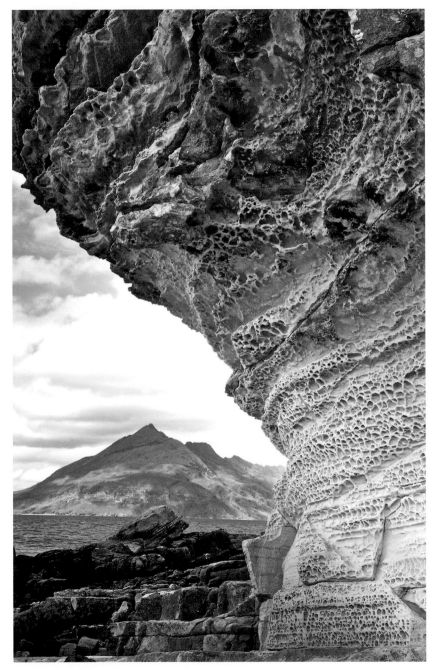

The longest, loneliest, loveliest glen in Scotland.

Sir Walter Scott (1771–1832) describing Glen Lyon

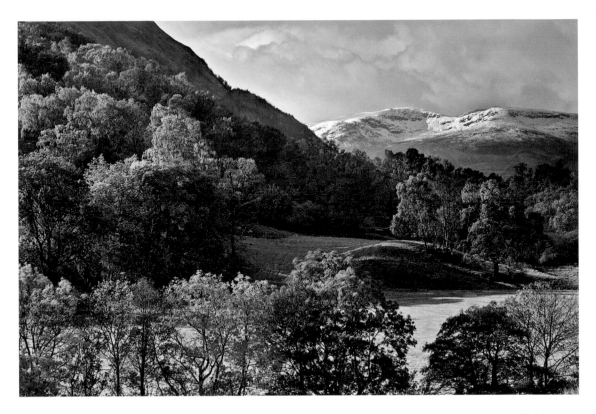

Glen Lyon, Perthshire

Behind the trees we heard the waterfall
Murmurous as life which is the voice of God;
And our own isolate life was quieted
Listening to this eternal murmur:
We were content, staring upon that sound,
To lose our voices in a greater voice;
To pause, and look, and listen, and be still.

from The Waterfall *by William Soutar* (1898–1943)

The Black Spout Waterfall, Pitlochry

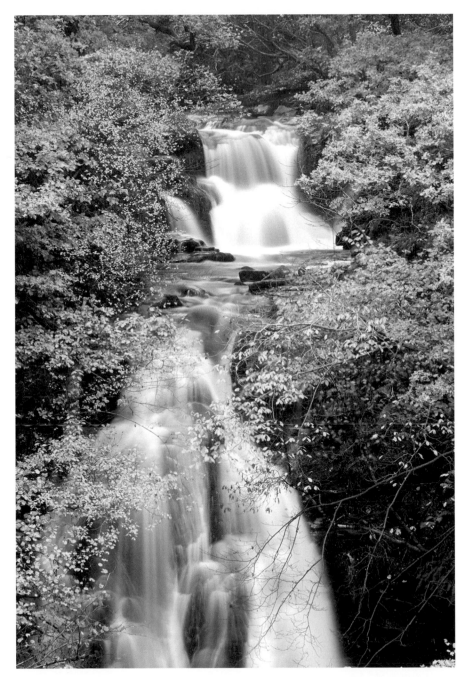

The Last Word...

The rose of all the world is not for me.
I want for my part
Only the little white rose of Scotland
That smells sharp and sweet – and breaks the heart.

The Little White Rose by Hugh MacDiarmid (1892–1978)

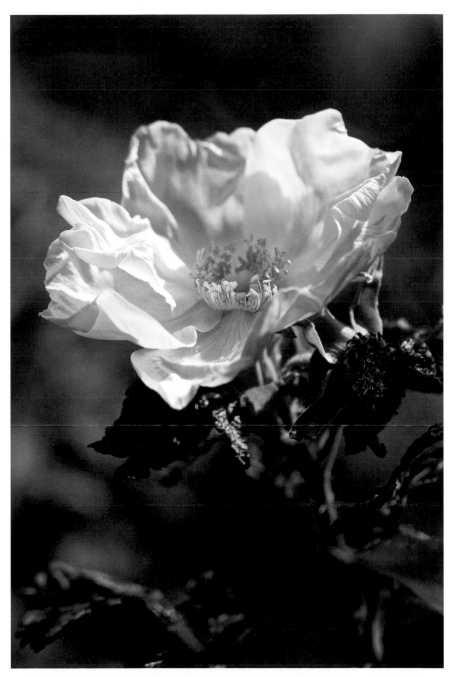

Luath Press Limited

committed to publishing well written books worth reading

LUATH PRESS takes its name from Robert Burns, whose little collie Luath (*Gael.,* swift or nimble) tripped up Jean Armour at a wedding and gave him the chance to speak to the woman who was to be his wife and the abiding love of his life. Burns called one of 'The Twa Dogs' Luath after Cuchullin's hunting dog in Ossian's *Fingal*. Luath Press was established in 1981 in the heart of Burns country, and now resides a few steps up the road from Burns' first lodgings on Edinburgh's Royal Mile.
Luath offers you distinctive writing with a hint of unexpected pleasures.

Most bookshops in the UK, the US, Canada, Australia, New Zealand and parts of Europe either carry our books in stock or can order them for you. To order direct from us, please send a £sterling cheque, postal order, international money order or your credit card details (number, address of cardholder and expiry date) to us at the address below. Please add post and packing as follows: UK – £1.00 per delivery address; overseas surface mail – £2.50 per delivery address; overseas airmail – £3.50 for the first book to each delivery address, plus £1.00 for each additional book by airmail to the same address. If your order is a gift, we will happily enclose your card or message at no extra charge.

Luath Press Limited
543/2 Castlehill
The Royal Mile
Edinburgh EH1 2ND
Scotland
Telephone: 0131 225 4326 (24 hours)
Fax: 0131 225 4324
email: sales@luath.co.uk
Website: www.luath.co.uk